# Draw
# Nature

## MOIRA HUNTLY

Series editors: David and Brenda Herbert

A & C Black • London

First published in 1981
New style of paperback binding 1998
by A&C Black Publishers Limited
38 Soho Square, London W1D 3HB
www.acblack.com

Reprinted 2003, 2007

ISBN: 978-0-7136-8780-4

Cover design by Emily Bornoff

Printed in China by WKT Company Limited

This book is produced using paper that is made from
wood grown in managed, sustainable forests. It is natural,
renewable and recyclable. The logging and manufacturing
processes conform to the environmental regulations
of the country of origin.

# Contents

# Making a start

The countryside, garden, park and seashore provide an endless source of interesting subjects for drawing—stones, leaves, grasses, fruits and flowers, shells and fossils, as well as the trees and hedgerows, fences, gates and rocks that are part of the landscape.

Take a sketchbook with you whenever possible so that when something catches your eye you can stop to sketch it. When I go for a walk I take a plastic bag containing a small rubber cushion and my sketch pad and pencils—and a rug, in cold weather. You can usually find somewhere to sit, and if the ground is wet you can put your feet on the plastic bag; there's nothing worse than cold wet feet!

Don't be in too much of a rush to start—take time to look for forms, shapes and textures that interest you. The more you learn to look, the more you will see.

Sit straight at whatever you are going to draw, to avoid having to turn your head all the time and getting a distorted view of your subject.

You can also collect things to take home, so that you can make detailed studies of them or use them to make still-life groups or as the basis for a design.

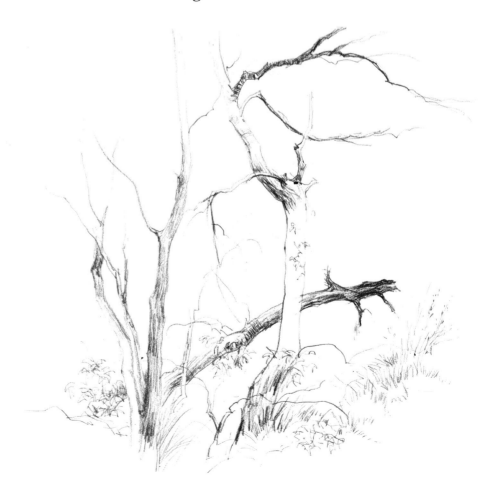

# What to draw on

Try as many different surfaces as possible.

**Ordinary, inexpensive paper** is often as good as anything else: for example, brown and buff wrapping paper (Kraft paper) and lining for wallpaper have surfaces which are particularly suitable for charcoal and soft crayons. Some writing and duplicating papers are best for pen drawings. But there are many papers and brands made specially for the artist.

**Bristol board** is a smooth, hard white board designed for fine pen work.

**Ledger Bond** (cartridge in the UK), the most usual drawing paper, is available in a variety of surfaces—smooth, 'not surface' (semi-rough), rough.

**Watercolour papers** also come in various grades of smoothness. They are thick, high-quality papers, expensive but pleasant to use.

**Ingres paper** is mainly for pastel drawings. It has a soft, furry surface and is made in many light colours—grey, pink, blue, buff, etc.

**Sketchbooks**, made up from nearly all these papers, are available. Choose one with thin, smooth paper to begin with. Thin paper means more pages, and a smooth surface is best to record detail.

**Lay-out pads** make useful sketchbooks. Although their covers are not stiff, you can easily insert a stiff piece of card to act as firm backing to your drawing. The paper is semi-transparent, but this can be useful—almost as tracing paper—if you want to make a new, improved version of your last drawing.

**An improvised sketchbook** can be just as good as a bought one—or better. Find two pieces of thick card, sandwich a stack of paper, preferably of different kinds, between them and clip together at either end.

# What to draw with

Pencils are graded according to hardness, from 6H (the hardest) through 5H, 4H, 3H, 2H to H; then HB; then B, through 1B, 2B, 3B, 4B, 5B up to 6B (the softest). For most purposes, a soft pencil (HB or softer) is best. If you keep it sharp, it will draw as fine a line as a hard pencil but with less pressure, which makes it easier to control. Sometimes it is effective to smudge the line with your finger or an eraser, but if you do this too much the drawing will look woolly. Pencil is the most versatile of all drawing techniques, suitable for anything from the most precise linear drawing to broad tonal treatment. Of course, a pencil line, even at its heaviest, is never a true black. But it has a lustrous, pewtery quality that is very attractive. A fine range of graphite drawing pencils is Royal Sovereign.

**Charcoal** (which is very soft) is excellent for large, bold sketches, but not for detail. Beware of accidental smudging; a drawing can even be dusted or rubbed off the paper altogether. To prevent this, spray with fixative.

**Wax crayons** (also soft) are not easily smudged or erased. You can scrape a line away from a drawing on good quality paper, or partly scrape a drawing to get special effects.

**Oil pastels**, marker pencils, chinagraph and lithographic chalk are similar to wax crayons.

**Conté crayons**, wood-cased or in solid sticks, are available in various degrees of hardness, and in several colours. The cased crayons are easy to sharpen, but the solid sticks are more fun—you can use the side of the stick for large areas of tone. Conté is harder than charcoal, but it is also easy to smudge. The black is very intense.

**Ball point pens** make a drawing look a bit mechanical, but they are cheap and fool-proof and useful for quick notes and scribbles.

**Fibre pens** are only slightly better, and their points tend to wear down quickly.

**Brushes** are very versatile drawing instruments. The biggest sable brush has a fine point, and the smallest brush laid on its side provides a line broader than the broadest nib. You can add depth and variety to a pen or crayon drawing by washing

CHARCOAL

PEN & INK

STICK & INK

BRUSH & INK

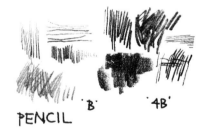

PENCIL

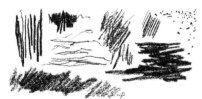

CONTÉ PENCIL

over it with a brush dipped in clean water.

**Mixed methods** are often pleasing. Try making drawings with pen and pencil, pen and wash or Conté and wash. And try drawing with a pen on wet paper. Pencil and Conté do not look well together and Conté will not draw over pencil or greasy surfaces.

**Pastels** (available in a wide range of colours) are softer still.

**Pens** vary as much as pencils or crayons. Ink has a quality of its own, but of course it cannot be erased. Mapping pens are only suitable for delicate detail and minute cross-hatching.

Special artists' pens, such as Gillott 303 and Gillott 404, allow you a more varied line, according to the angle at which you hold them and the pressure you use. The Gillott 659 is a very popular crowquill pen.

Reed, bamboo and quill pens are good for bold lines and you can make the nib end narrower or wider with the help of a sharp knife or razor blade. This kind of pen has to be dipped frequently into the ink.

**Fountain pens** have a softer touch than dip-in pens, and many artists prefer them.

Special fountain pens, such as Rapidograph and Rotring, control the flow of ink by means of a needle valve in a fine tube (the nib). Nibs are available in several grades of fineness and are interchangeable. The line they produce is of even thickness, but on coarse paper you can draw an interesting broken line similar to that of a crayon.

**Inks** also vary. Waterproof Indian ink quickly clogs the pen. Pelikan Fount India, which is nearly as black, flows more smoothly and does not leave a varnishy deposit on the pen. Ordinary fountain-pen or writing inks (black, blue, green or brown) are less opaque, so give a drawing more variety of tone. You can mix water with any ink in order to make it thinner. But if you are using Indian ink, add distilled or rain water, because ordinary water will cause it to curdle.

**Drawing with ink**. Only practice will give you the confidence to use the pen as you would a pencil. Draw freely, and do not worry about mistakes—they can become an integral part of the development of the drawing, and even a blot can look good!

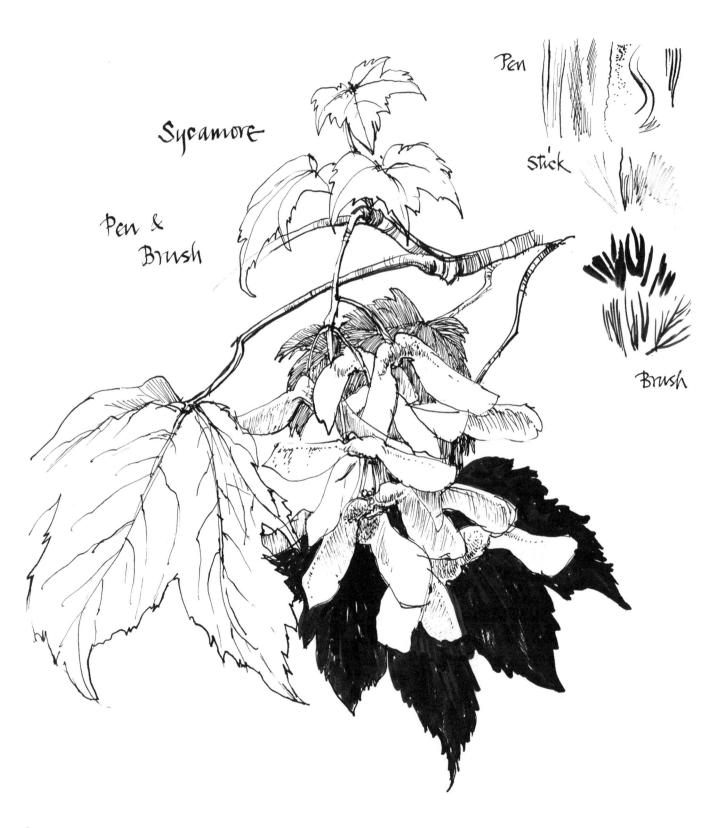

Pen

Stick

Brush

Sycamore

Pen & Brush

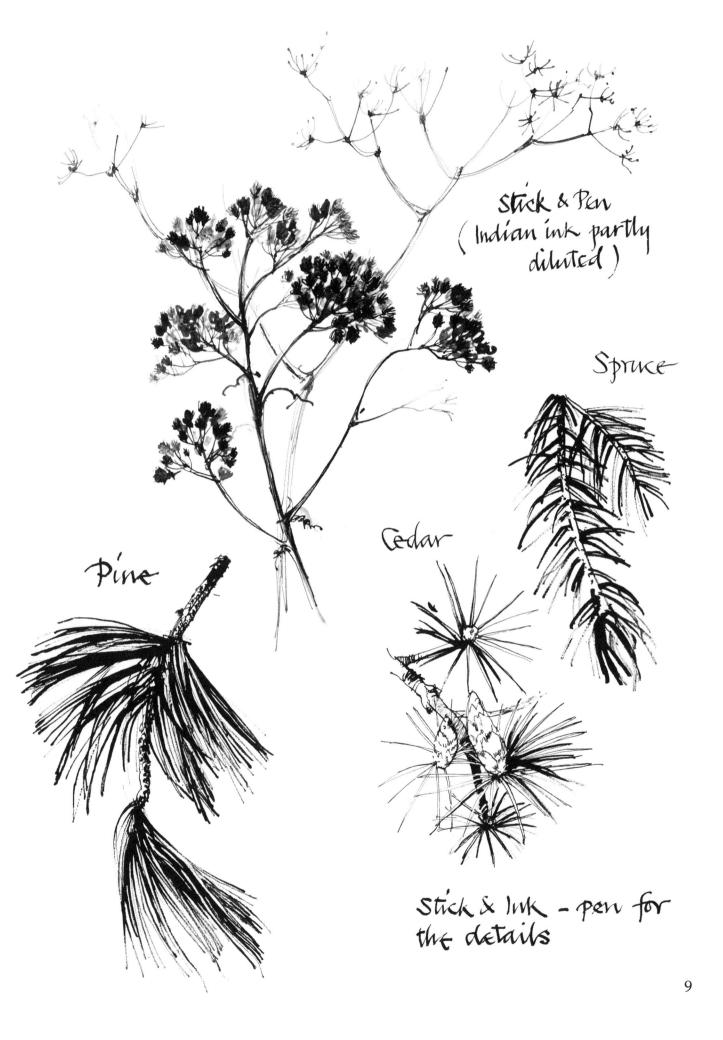

Stick & Pen
( Indian ink partly
diluted )

Spruce

Cedar

Pine

Stick & Ink – pen for
the details

9

# Perspective

It is not necessary to know much about the rules of perspective in order to draw from nature, but if you want to include, for example, a fence, a pathway or part of a building in your drawing, or to extend it into a landscape study, the following may help.

All receding parallel lines that go away from you into the distance will appear to converge at eye-level at the same vanishing point. All lines *above* your eye-level slope *down* to the vanishing point. All lines below your eye-level slope up to the vanishing point. As you will see in the diagram, the width between the posts of a fence (or between any parallel vertical lines) also diminishes as they get further away.

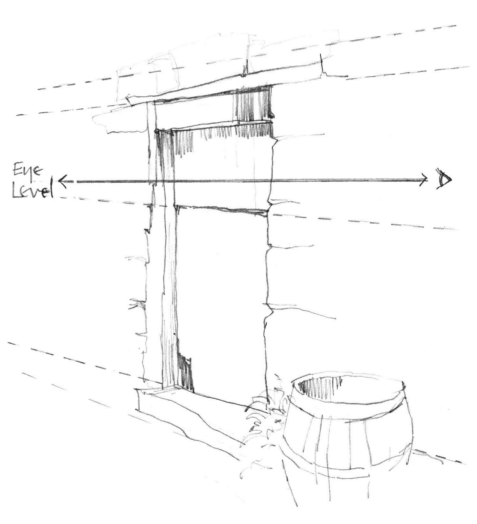

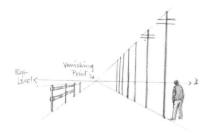

I started the drawing on the next page, as shown here, by noticing that the top of the door was above my eye level and sloped down from the side nearest me. The centre division in the door was just below my eye level, so it slopes slightly up towards the vanishing point (which is off the page). The bottom of the door slopes up even more because it is lower.

This old farm doorway was drawn with a 6B pencil, kept well sharpened for the fine lines.

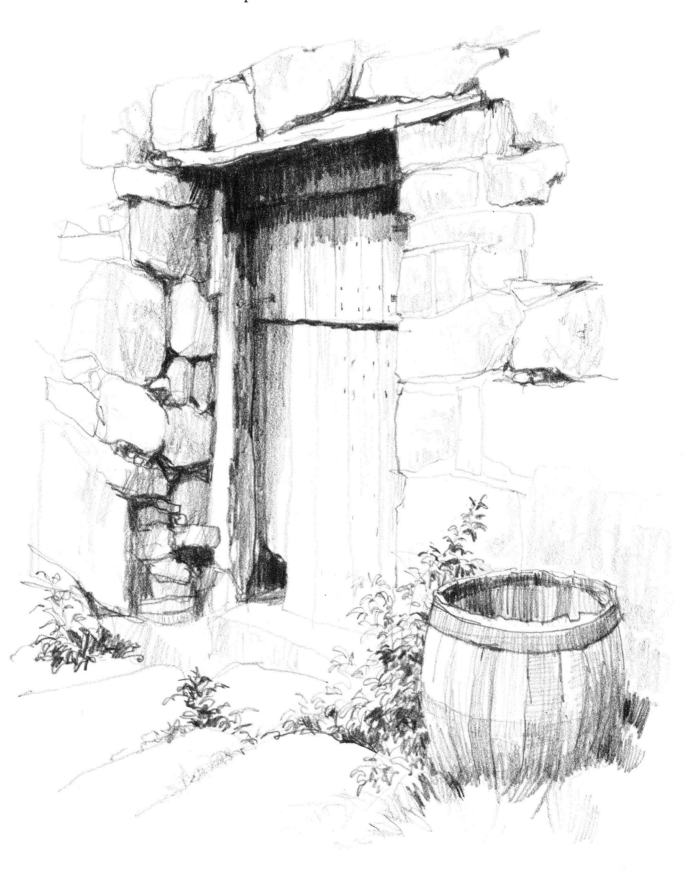

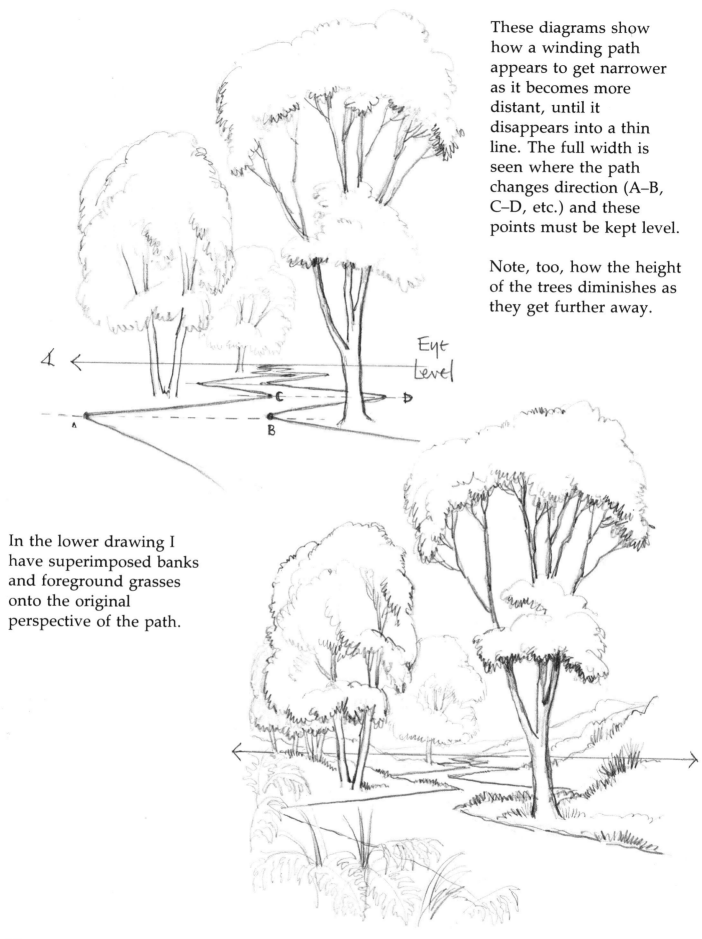

These diagrams show how a winding path appears to get narrower as it becomes more distant, until it disappears into a thin line. The full width is seen where the path changes direction (A–B, C–D, etc.) and these points must be kept level.

Note, too, how the height of the trees diminishes as they get further away.

In the lower drawing I have superimposed banks and foreground grasses onto the original perspective of the path.

This pencil drawing was
made with a 2B pencil,
using it lightly for the
distant trees and keeping
the strongest darks for
the one in the
foreground.

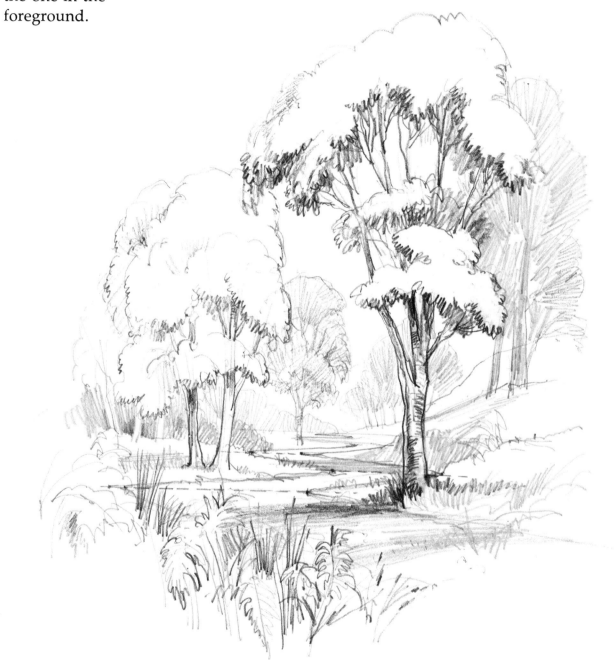

# Composition

Before you start to draw, think about the arrangement of your drawing on the paper. Try to see the subject as a silhouette shape and place it to achieve a balance. A good composition should not be confusing, there should be a focal point.

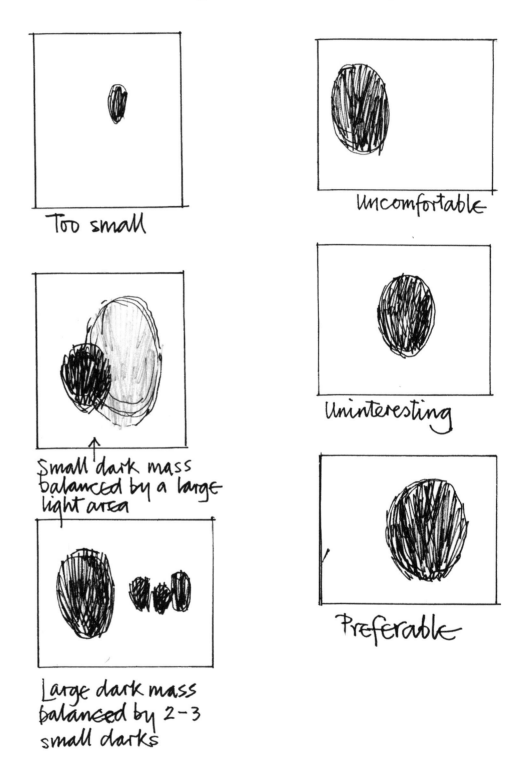

Too small

Uncomfortable

Small dark mass balanced by a large light area

Uninteresting

Large dark mass balanced by 2-3 small darks

Preferable

# Selecting a subject from the landscape

**Fences and gates** are simple man-made additions to the landscape that provide interesting shapes and detail. An old, uneven gate or fence is more exciting to draw than one that is too new and regular. Look to see what they are made of and how they are constructed. Compare the widths between the posts and their relative height. The base is usually lost in a tuft of grass.

The finished drawing of the broken fence was made in pencil. Notice that sometimes the posts are dark against light, and sometimes light against dark.

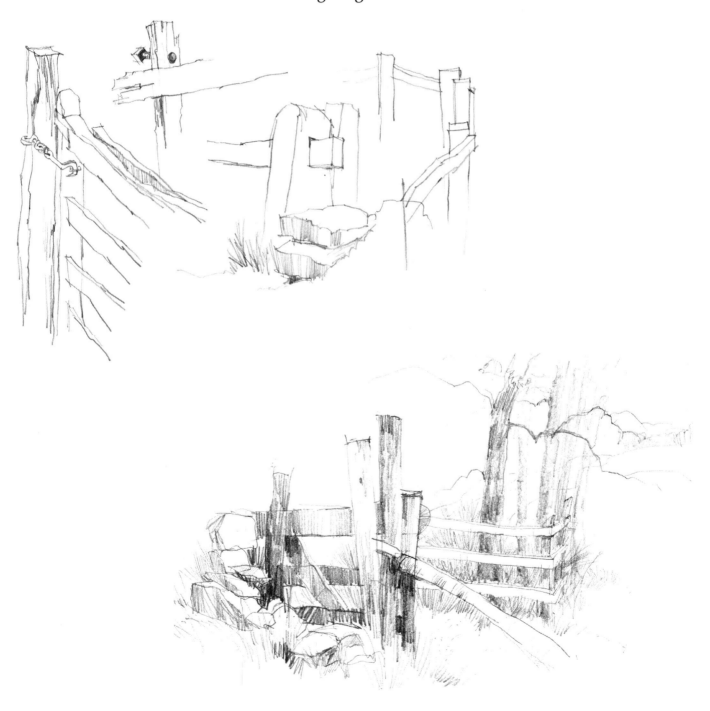

The gaps between the horizontal bars of the five-bar gate are narrower at the base, to prevent animals from getting their heads stuck. It is easier to draw the horizontal bars first and the cross-bars afterwards. The cross-bars meet in the centre of the gate, but when seen in perspective the nearest half of the gate appears to be wider. The angle of the bars depends on your eye-level and will vary according to whether you are standing up or sitting down to draw.

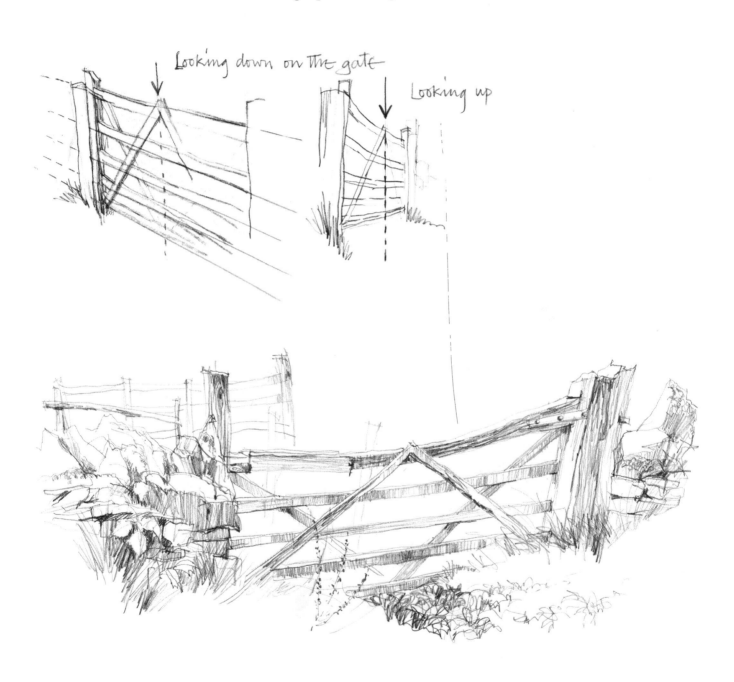

Looking down on the gate

Looking up

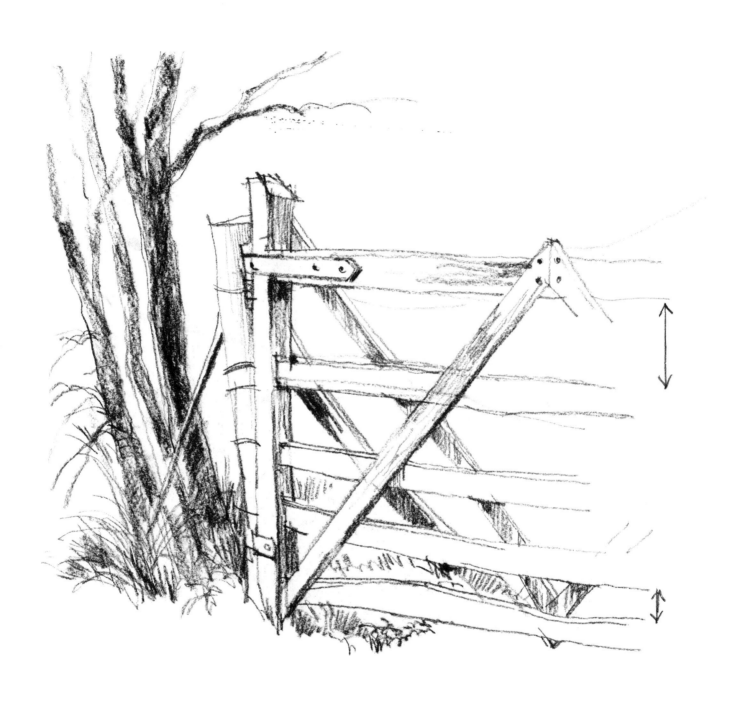

**Stone walls** have fascinating shapes and textures. Look at their construction, see how the stones are fitted together and how they are finished off at the top. There is often a variety of stone size between the top and bottom of the wall.

The upper sketch on the opposite page was made with a fibre-tip pen, and the one below with a Conté pencil. Some shading with a 2B pencil adds tone to the walls, and the pattern made by the walls across the field becomes more apparent.

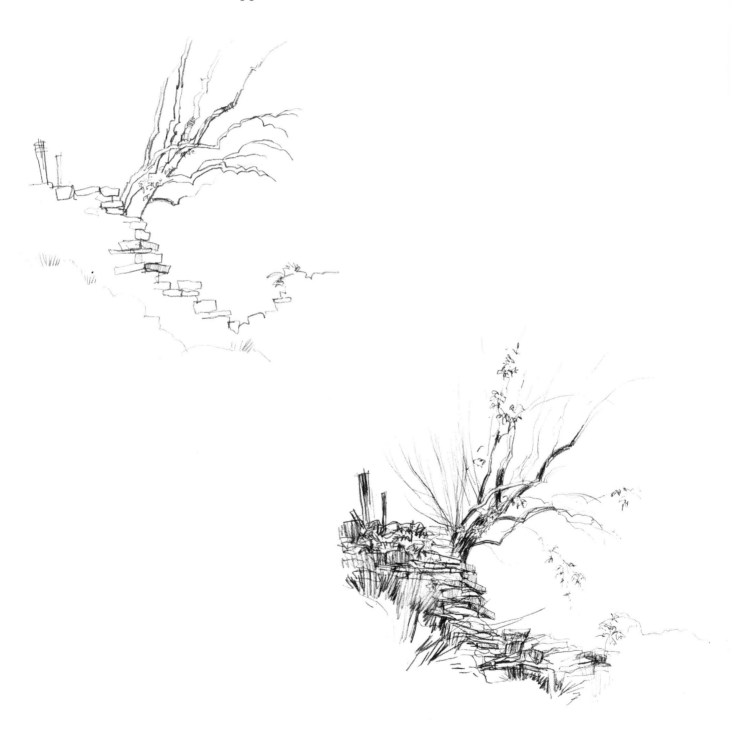

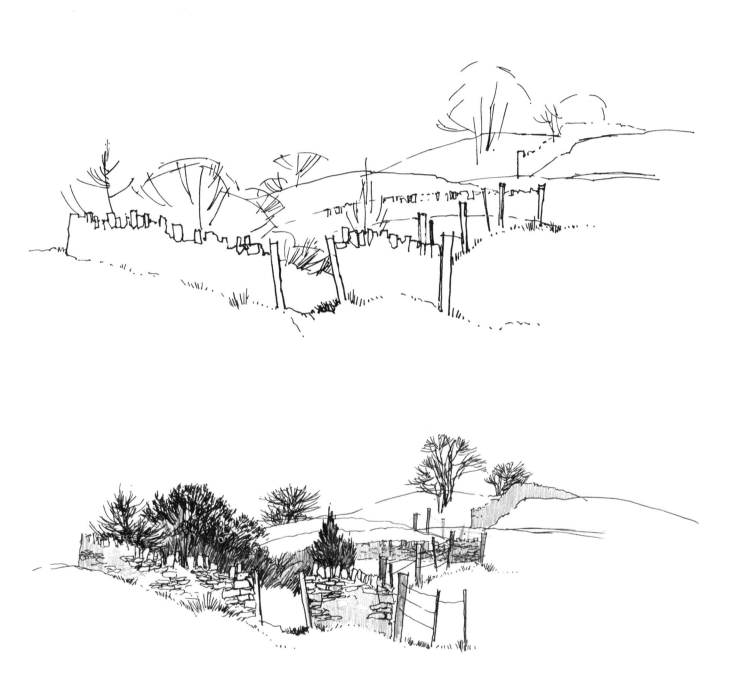

**Water**. The edge of a stream is usually dark where it reflects the bank, and the middle of the stream is light where it reflects the sky.

These charcoal drawings of a tree reflected in a pool show the difference between calm water and disturbed water. When the surface is rippled by wind or current, the edge of the reflection is broken up.

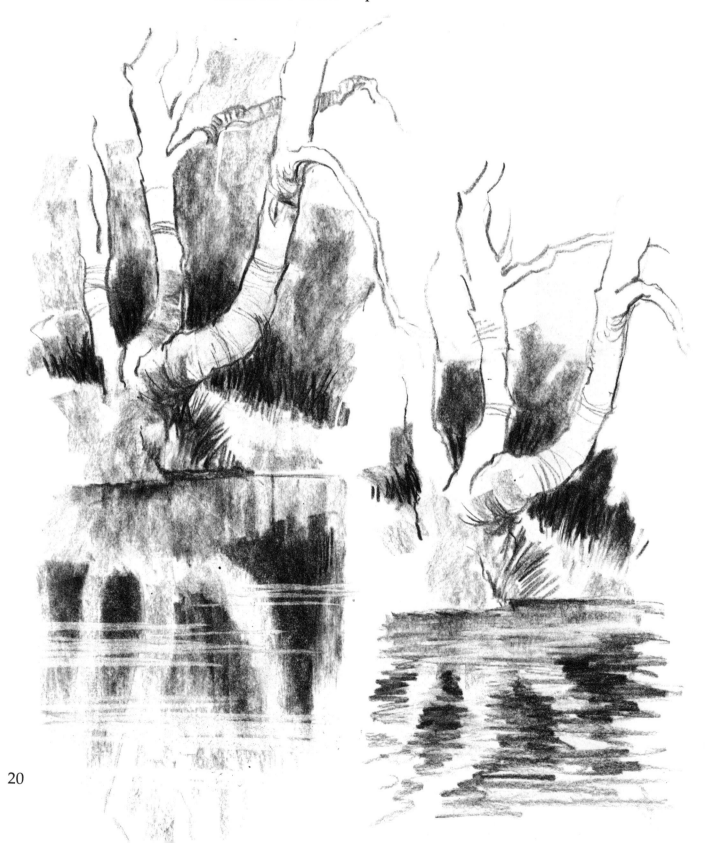

The bridge was drawn with a 2B pencil. Notice that the dark part of the reflection is drawn partly with vertical pencil strokes; this helps to give a limpid, liquid look to the calm water. Use some horizontal lines in the water to indicate that the surface is quite level—on the charcoal drawing opposite I have used an eraser to do this.

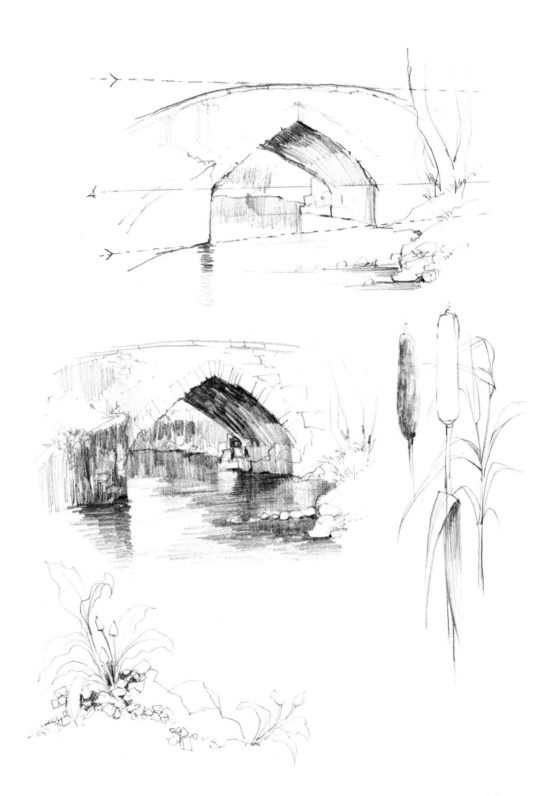

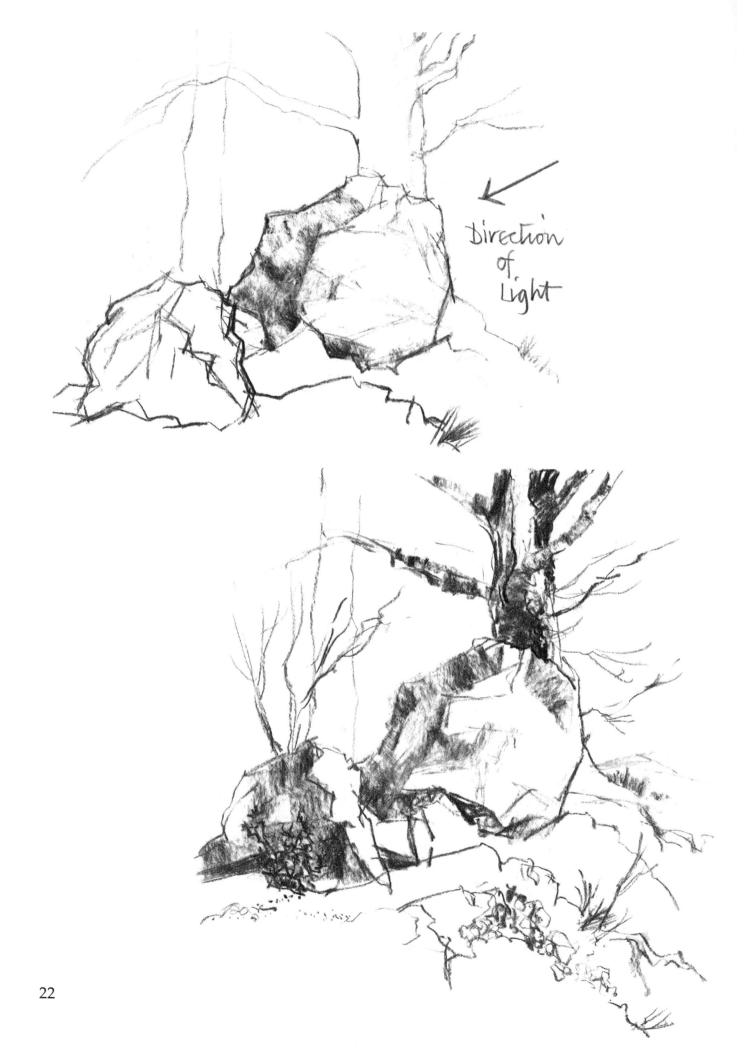

Direction
of
Light

**Rocks**. The boulders on the left were drawn with charcoal. The flowing lines of the trees contrast with the sharp, angular lines of the rock. After drawing the outlines, I looked for the direction of light and then built up the shadow. It is useful to break off a short length of charcoal and use it on its side for shading.

The drawing below was made with a 6B pencil, sharpened to a long point and used on its side for some of the shading, and changing the direction of the lines to indicate the angular planes of the rocky outcrop.

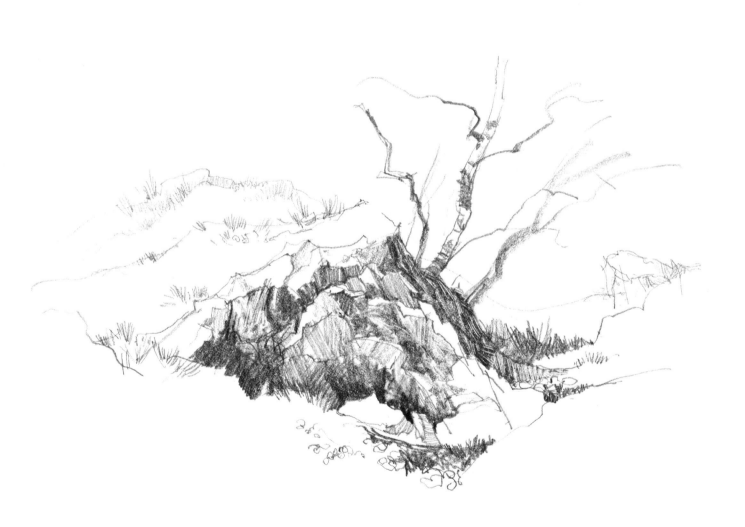

# Finding natural objects to draw

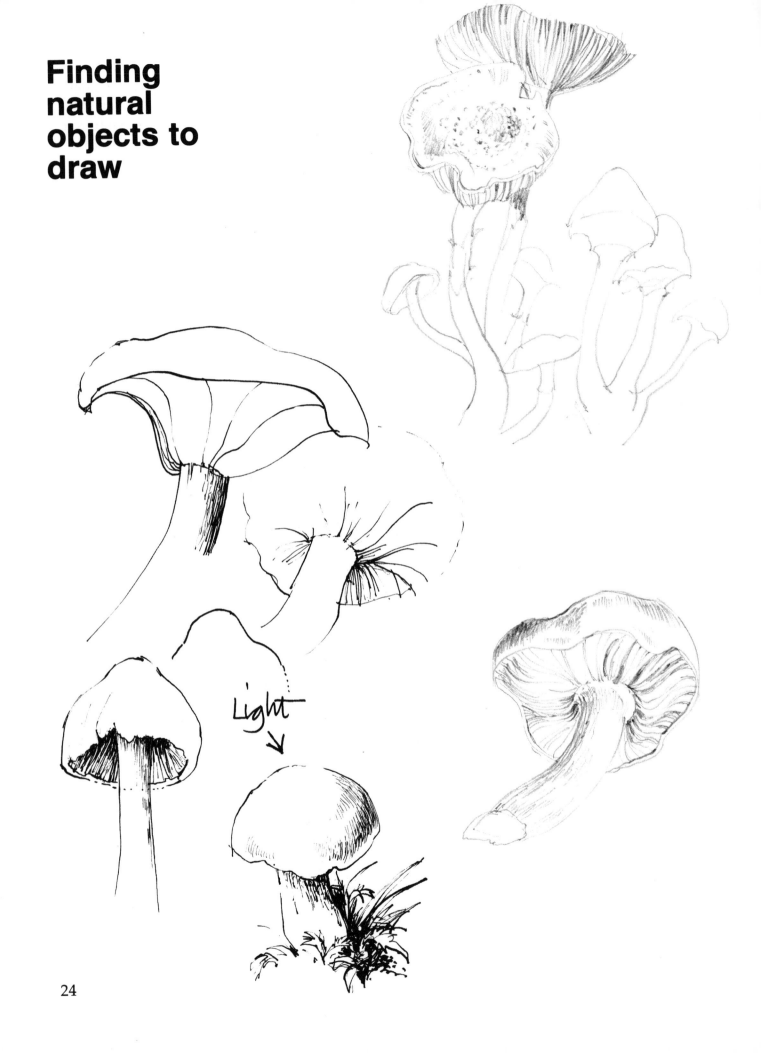

Light

Fungi have lovely curving shapes. Draw the flowing lines first, then notice the direction of light. Look for the roundness of the stalk as it fits into the cap. Use extra darks under the cap, and notice that the position of the tip of the cap relates to the direction of the stalk.

The drawing below was made directly with pen and ink—with no preliminary sketching in pencil.

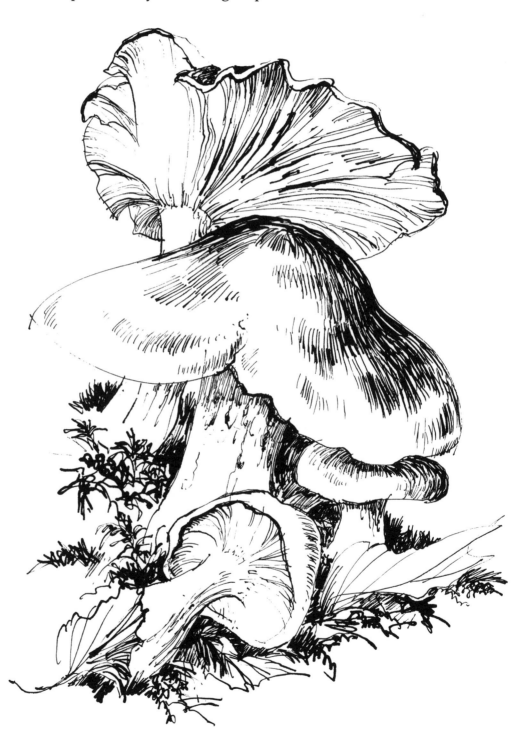

Fossils have simple, sometimes crumbly forms within which can be seen fine details. Here I have used a combination of charcoal pencil and a finely sharpened 2B pencil.

Ammonite

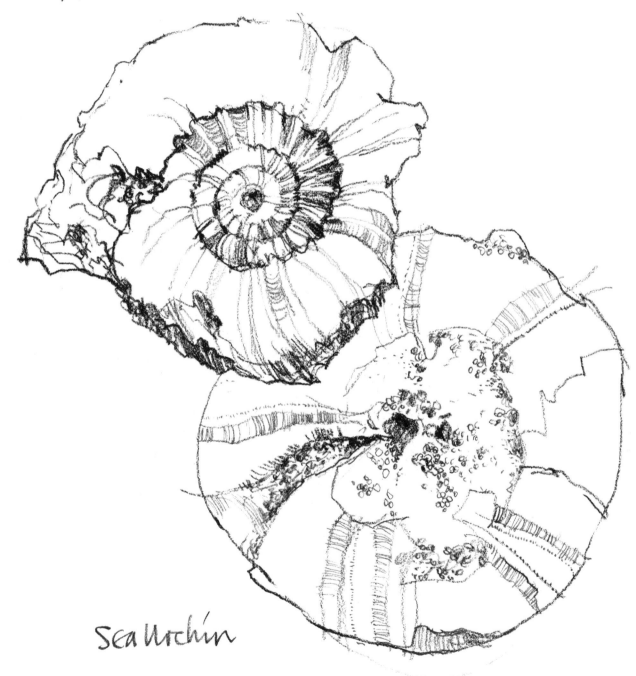

Sea Urchin

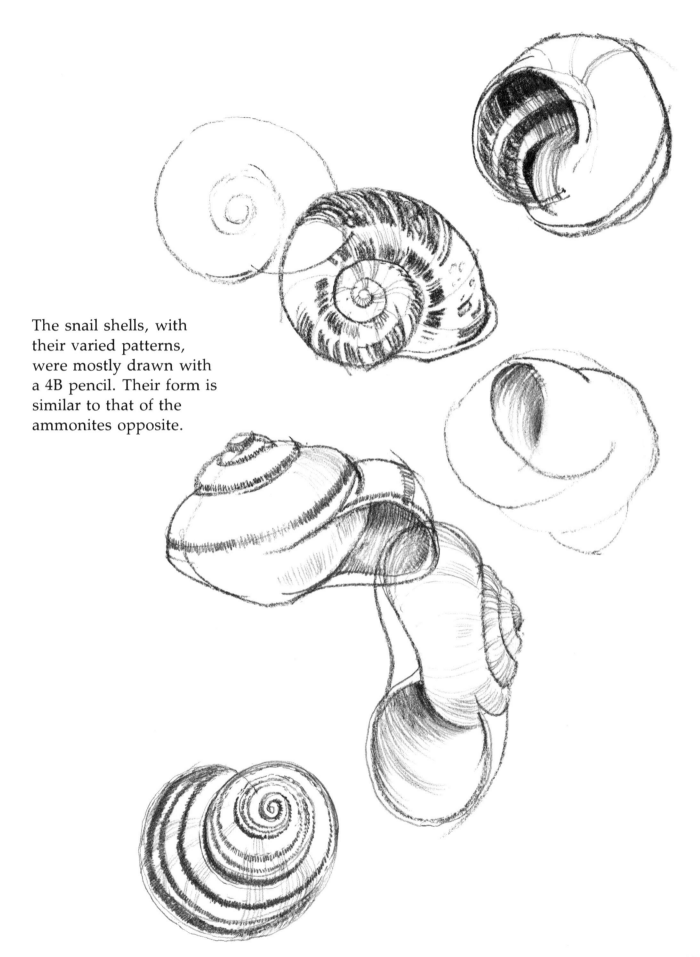

The snail shells, with their varied patterns, were mostly drawn with a 4B pencil. Their form is similar to that of the ammonites opposite.

In these studies of the horse-chestnut fruits or 'conkers', and the beechnuts and acorns, I was interested in the surface markings and various textures. A fibre-tip pen was used for the top group of quick studies, and a mixture of Indian ink and pencil for the acorns.

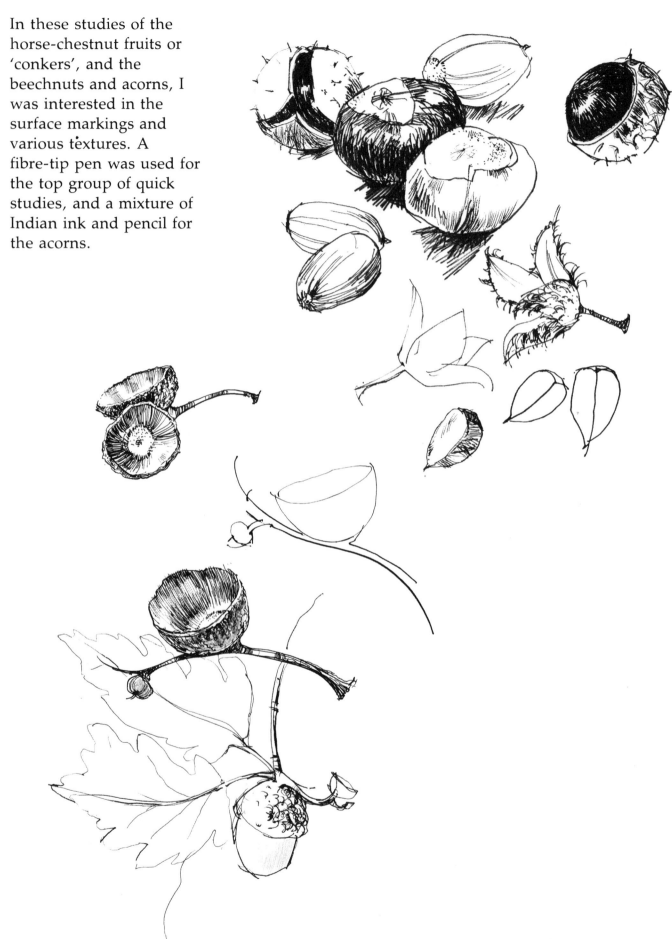

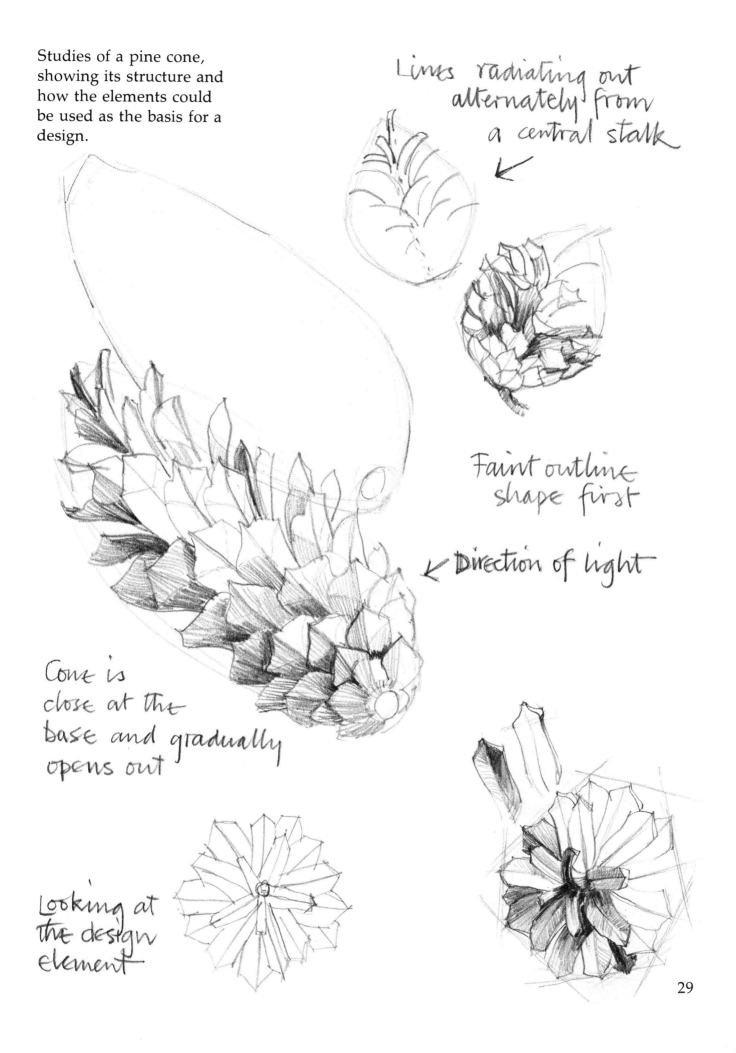

Studies of a pine cone, showing its structure and how the elements could be used as the basis for a design.

Lines radiating out alternately from a central stalk

Faint outline shape first

← Direction of light

Cone is close at the base and gradually opens out

Looking at the design element

This broken piece of branch, picked up on a walk, was brought home to draw. A simple outline was made with Conté pencil and then the general light and shade was added to give meaning to the twisted form. Textures and detail were gradually added, taking care not to lose the light and shade by overdoing the detail. Finally a fixative spray was used on the drawing—you will find that Conté pencil smudges very easily.

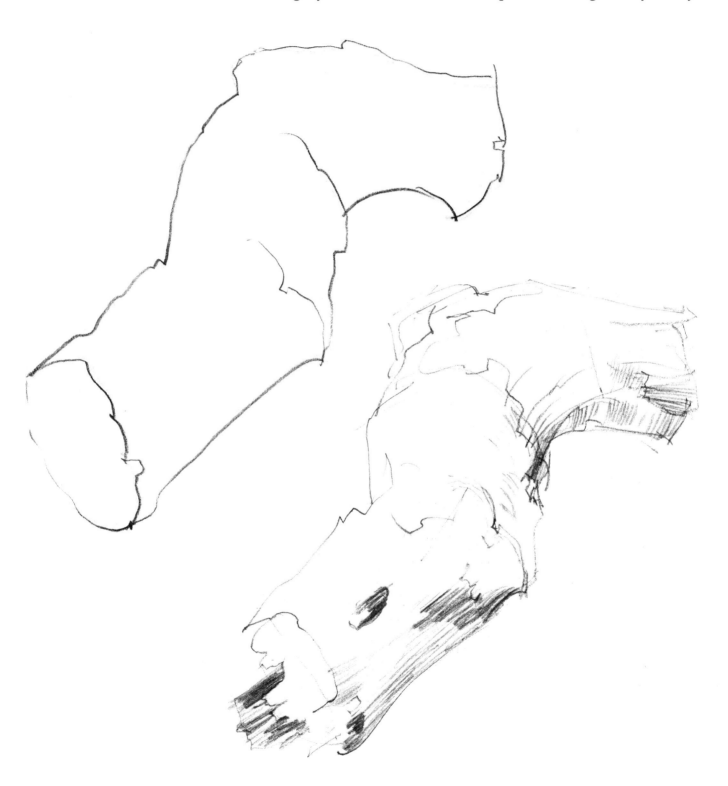

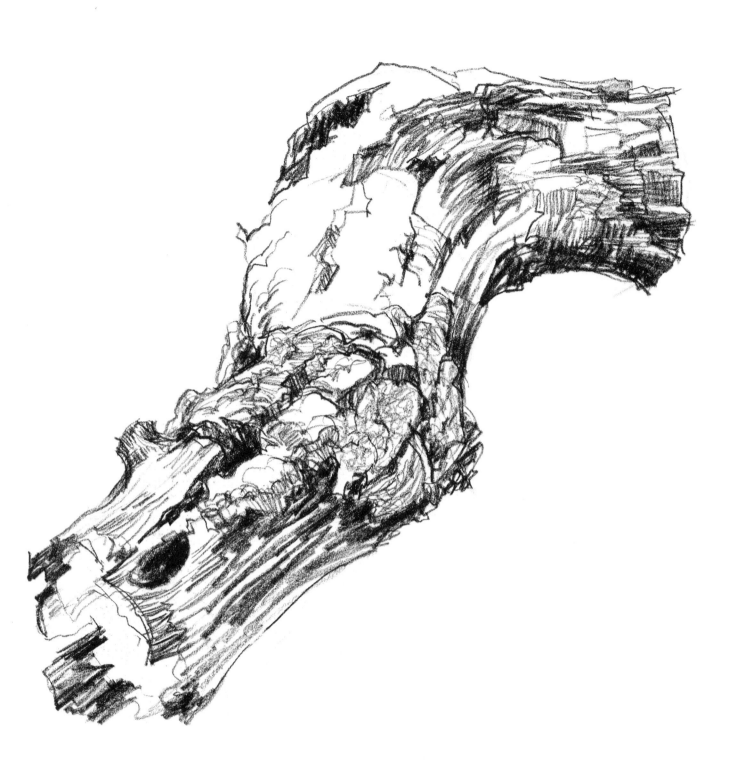

Tree-bark has fascinating patterns and varies greatly with different kinds of tree. This piece of deeply-indented bark, with its angular planes, was drawn with a Conté pencil. The drawing was fixed, and then washes of subtle watercolour were freely applied.

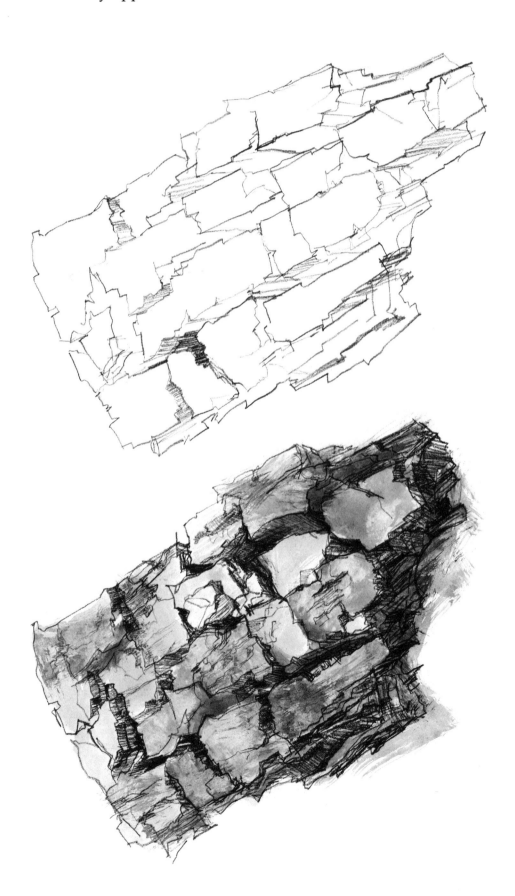

There is a lot of interest to be found between the roots of a big tree—stones, lichen, grasses and weeds. These have been drawn with a larger nib size and Indian ink, loading the pen fully to put in the darks.

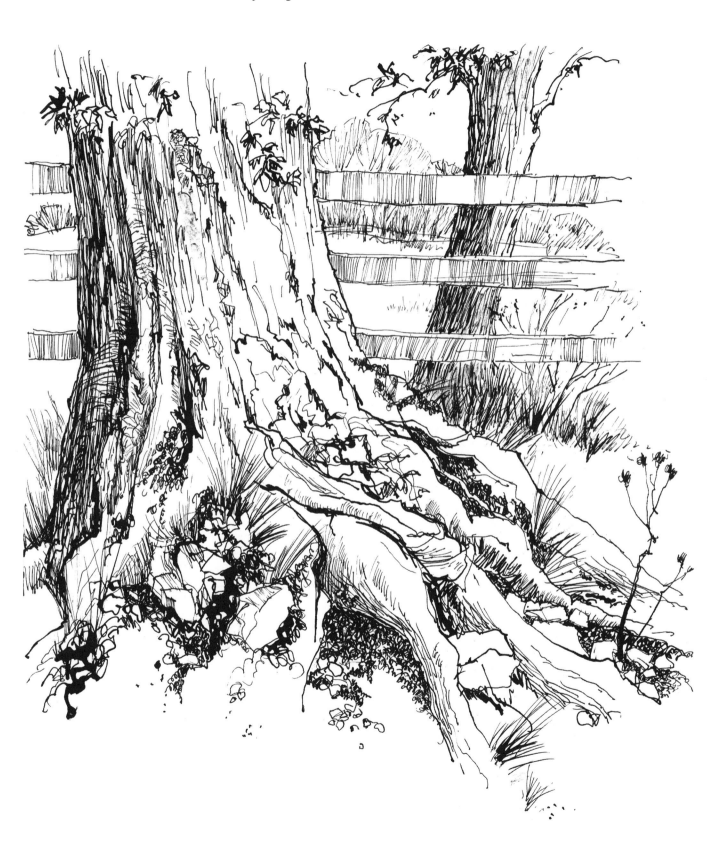

This piece of root had such an interesting abstract shape that I carried it half way down a mountain in Wales and took it home to draw. The form is complicated, so I drew the outline in Conté pencil first, then concentrated on the main shadows. Details were added with a mixture of charcoal pencil and 4B pencil.

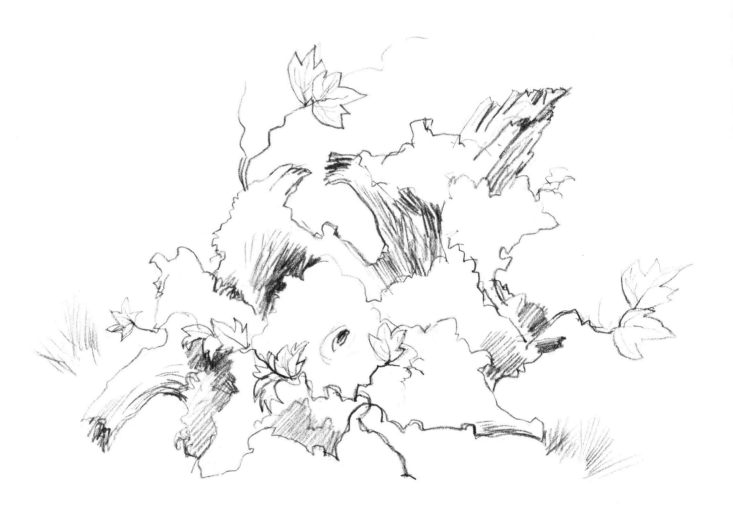

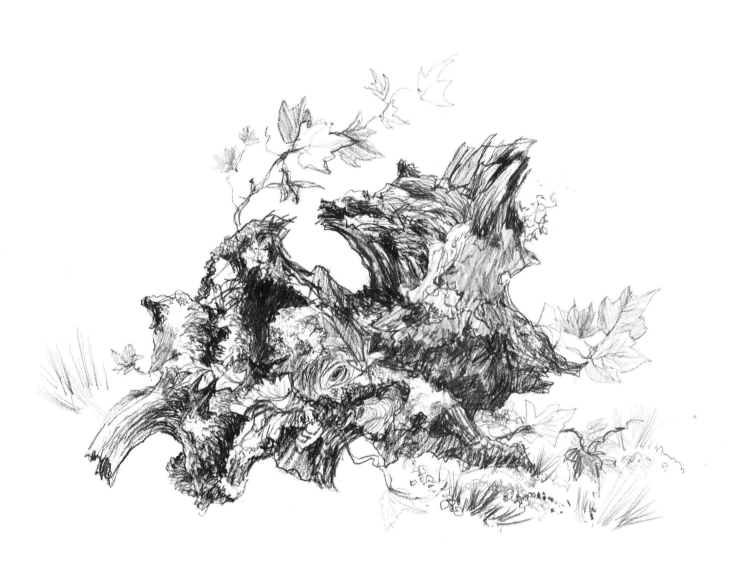

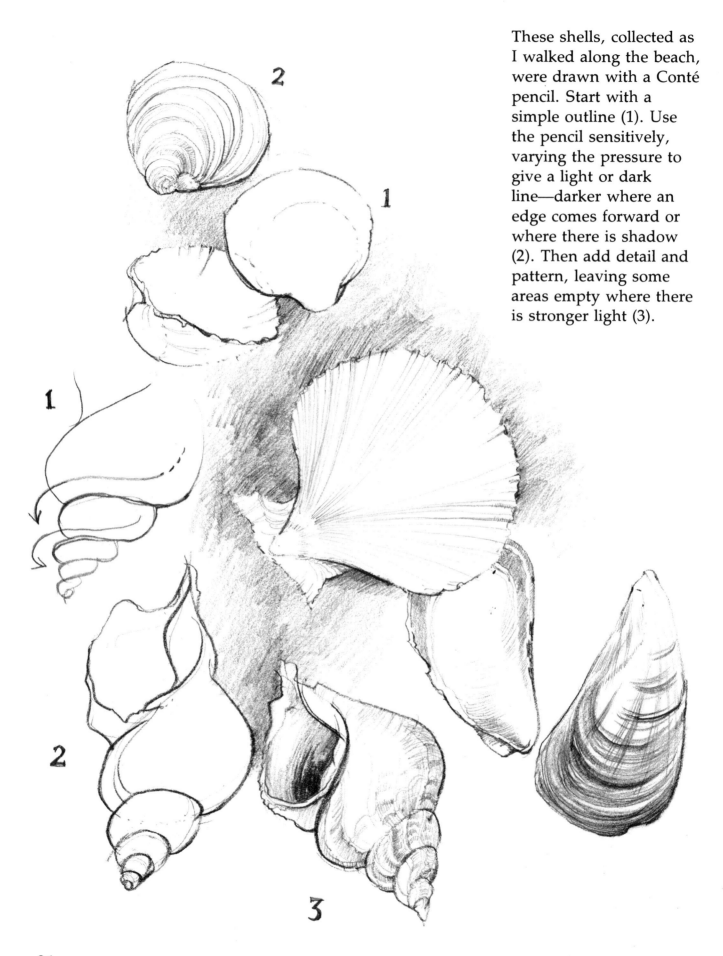

These shells, collected as I walked along the beach, were drawn with a Conté pencil. Start with a simple outline (1). Use the pencil sensitively, varying the pressure to give a light or dark line—darker where an edge comes forward or where there is shadow (2). Then add detail and pattern, leaving some areas empty where there is stronger light (3).

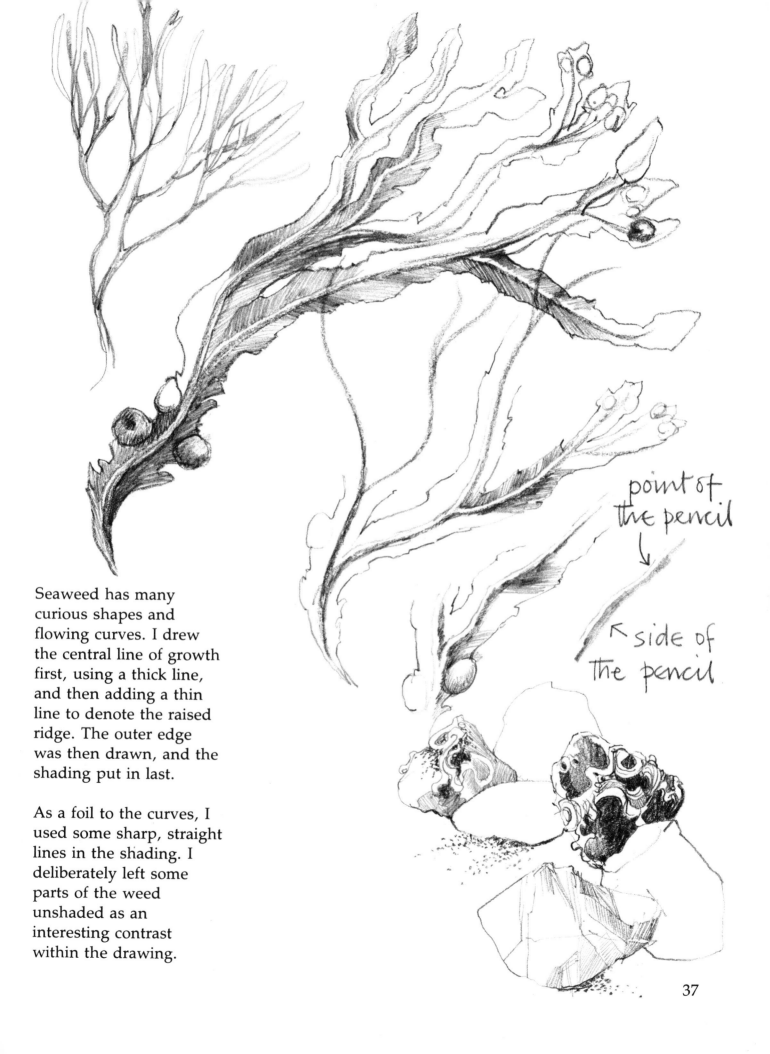

Seaweed has many curious shapes and flowing curves. I drew the central line of growth first, using a thick line, and then adding a thin line to denote the raised ridge. The outer edge was then drawn, and the shading put in last.

As a foil to the curves, I used some sharp, straight lines in the shading. I deliberately left some parts of the weed unshaded as an interesting contrast within the drawing.

point of the pencil

side of the pencil

# Looking for detail

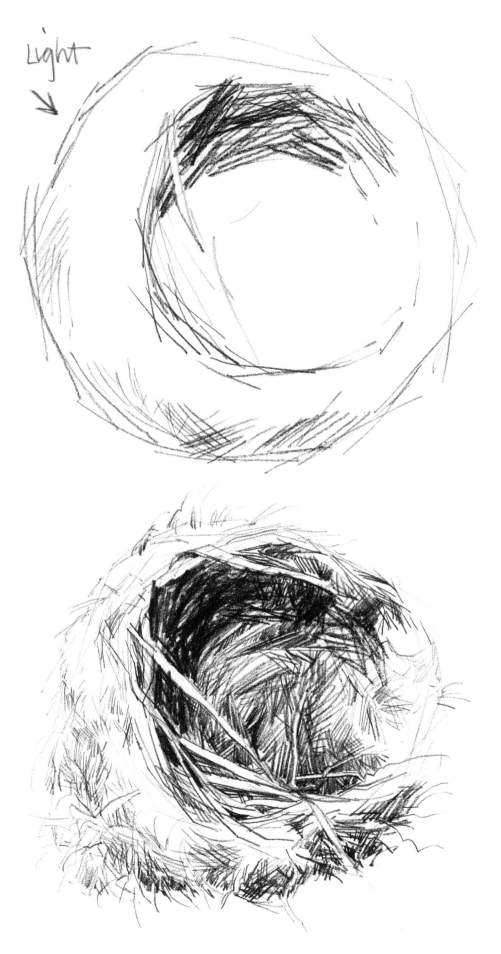

Light

The bird's nest was abandoned and had fallen to the ground, so I took it home to draw. It was full of amazing detail, so I drew in the general shape with a charcoal pencil, then observed the direction of light and started to shade with a cross-hatching technique, which seemed to suit the interwoven quality of the nest.

Feathers can also be picked up and observed in detail. They are useful too, if you can cut your own quill and then draw with it!

As a contrast to the texture of the bird's nest I have used several washes of watercolour and then added a few pen lines, to indicate the fine smoothness of the feather.

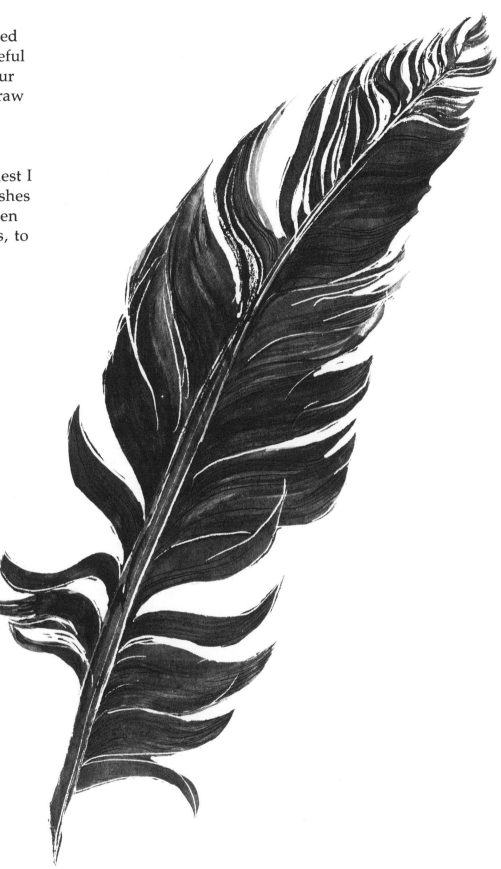

Look for detail in the way trees and plants grow.

The delicate catkins of the alder have been drawn with a light and sometimes broken outline, with pen and ink. The stems have a firmer, more flowing line and the catkins hang down gracefully, whereas the little cones grow upwards.

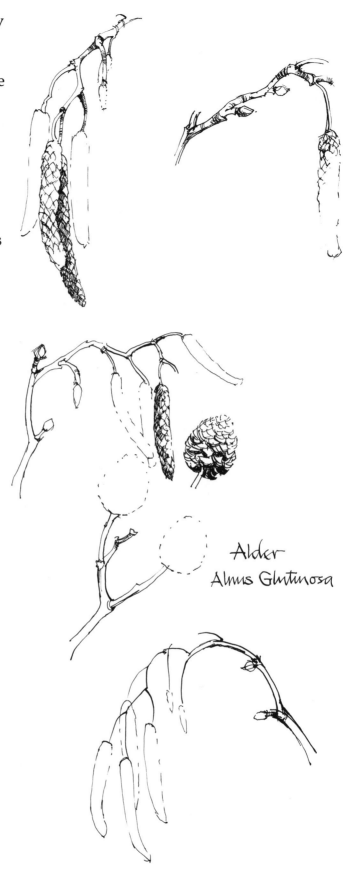

Alder
Alnus Glutinosa

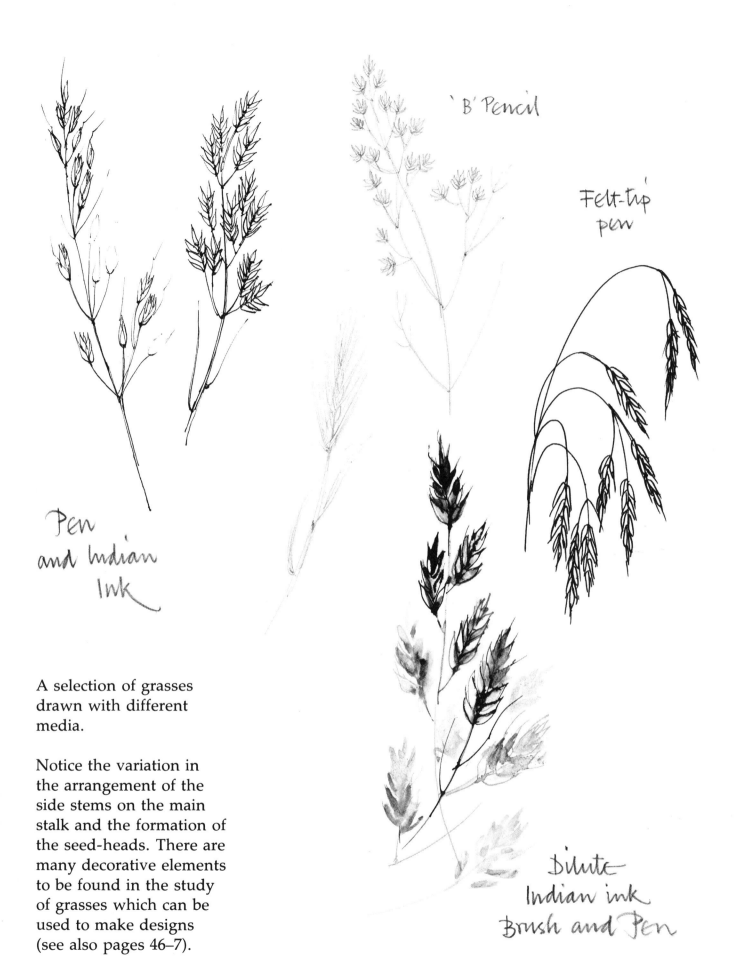

'B' Pencil

Felt-tip
pen

Pen
and Indian
Ink

Dilute
Indian ink
Brush and Pen

A selection of grasses
drawn with different
media.

Notice the variation in
the arrangement of the
side stems on the main
stalk and the formation of
the seed-heads. There are
many decorative elements
to be found in the study
of grasses which can be
used to make designs
(see also pages 46–7).

There is a pleasing
contrast between the
texture of a stone wall
and the movement of the
ivy growing out of the
crevices. The ivy stems
seem to writhe about like
snakes, and I like the
pattern of the berries.

Here I have used a
combination of charcoal
pencil and 6B pencil.

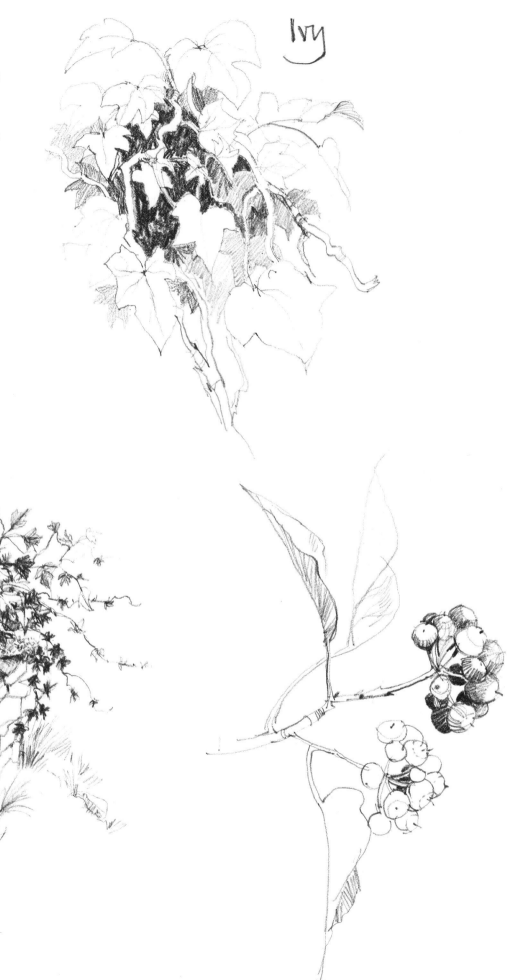

Ivy

These drawings of ivy were made with a fibre-tip pen. Notice the pattern of the leaf veins, and how the leaves appear light against the dark tree trunk and dark against the lighter background.

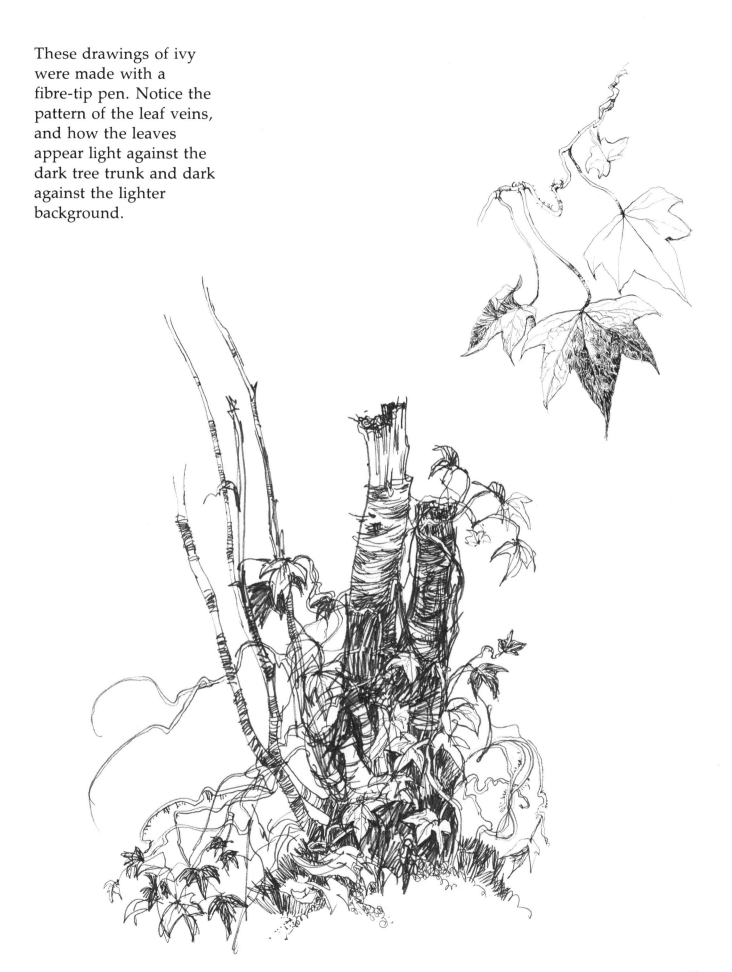

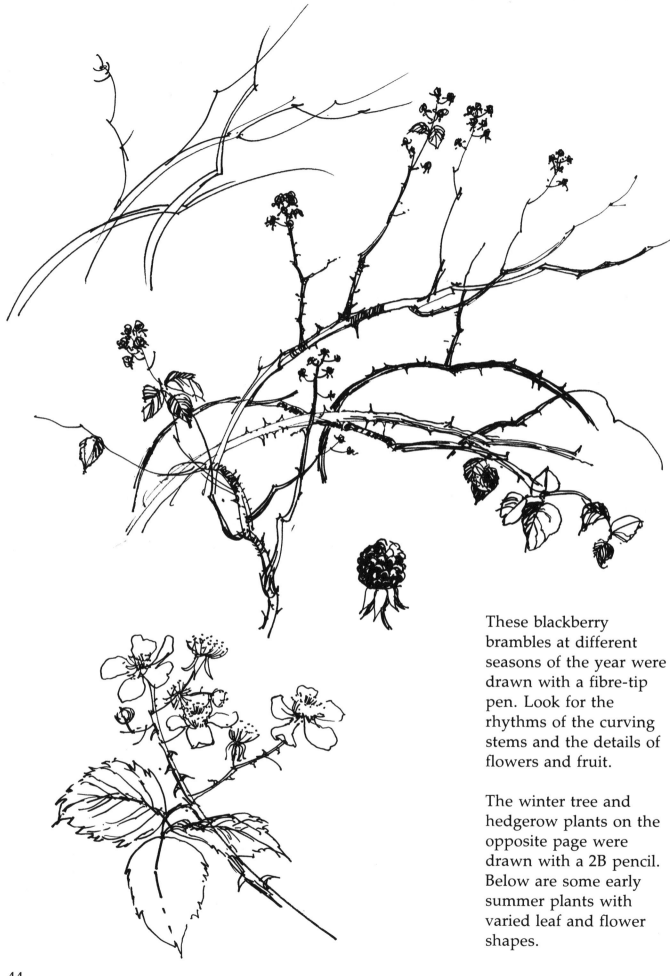

These blackberry brambles at different seasons of the year were drawn with a fibre-tip pen. Look for the rhythms of the curving stems and the details of flowers and fruit.

The winter tree and hedgerow plants on the opposite page were drawn with a 2B pencil. Below are some early summer plants with varied leaf and flower shapes.

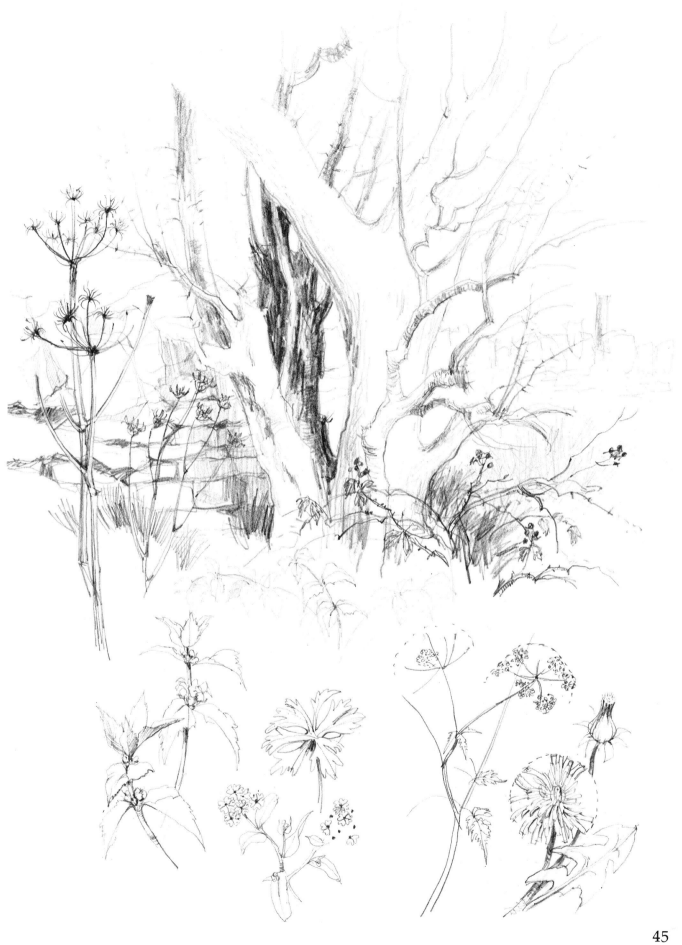

# Designs from nature

All sorts of fascinating forms and patterns can be found in nature. Further study can provide endless subject matter for both figurative and abstract designs.

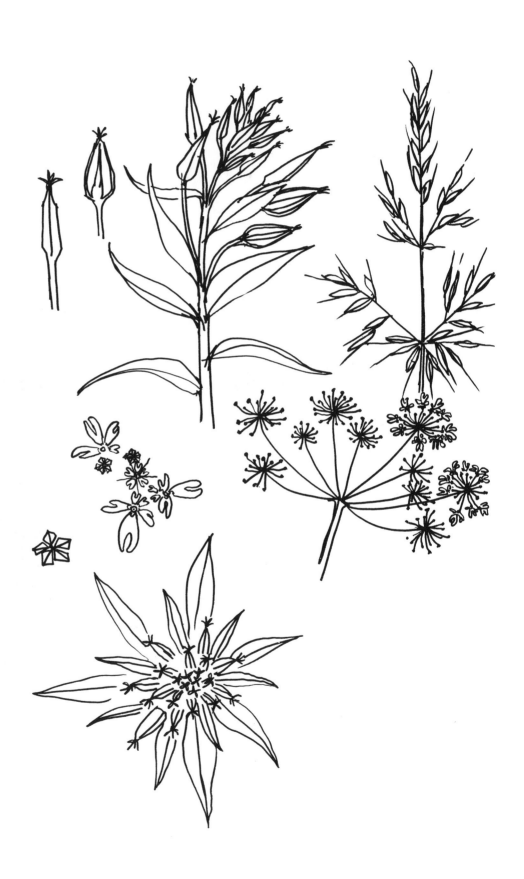

The decorative sketches on the opposite page were made with a fibre-tip pen.

This drawing was made on black cartridge paper with white Conté and with a pen and white ink.

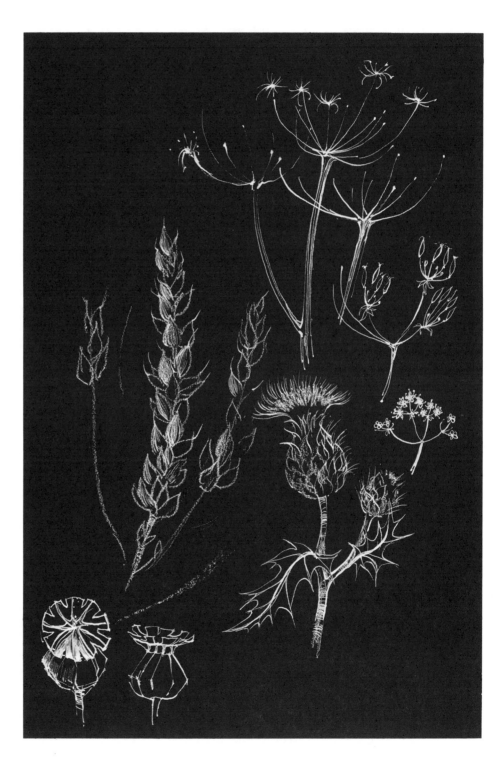

This final sketch was made with a 2B pencil. The tone on the trunks of the trees changes from light to dark under the leaves and there are many different types of foliage.

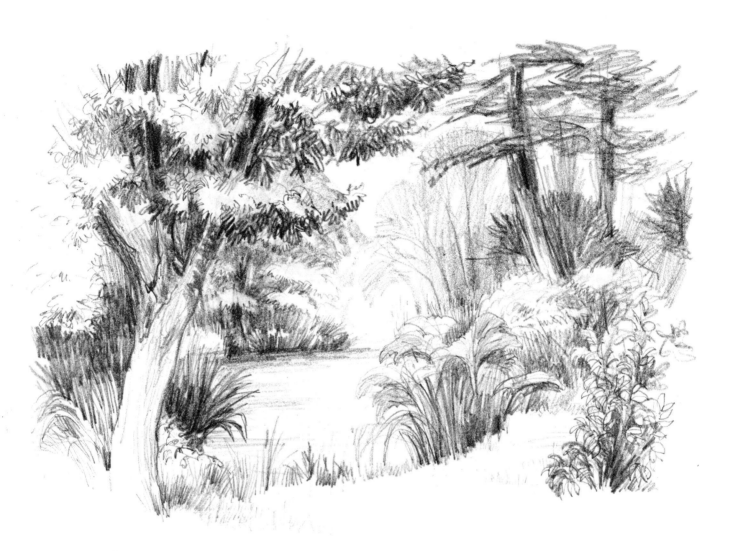

Trunks changing from
light to dark under the leaves
Variation of foliage